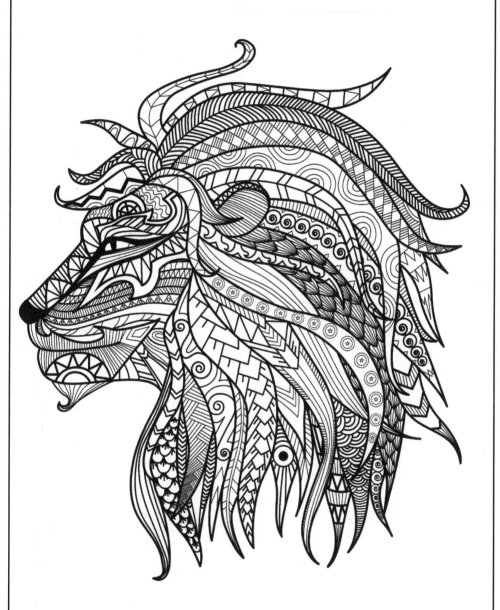

*Animal Design 1*

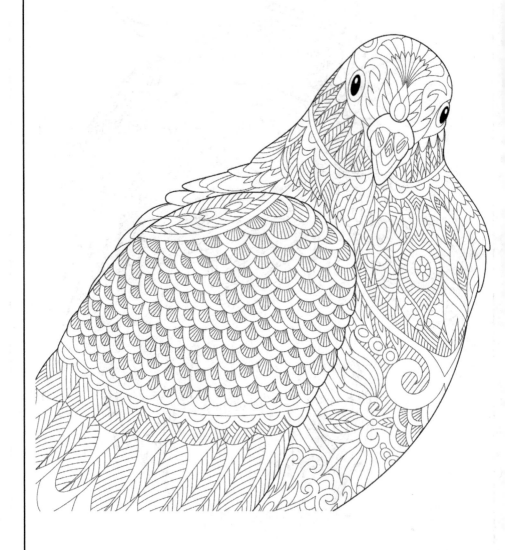

*Animal Design 2*

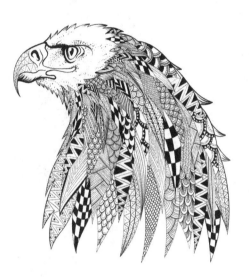

*Animal Design 3*

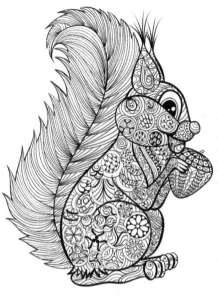

*Animal Design 4*

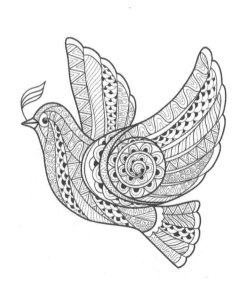

*Animal Design 5*

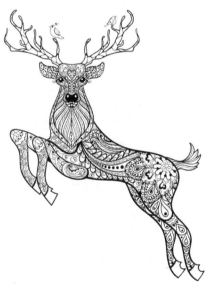

*Animal Design 6*

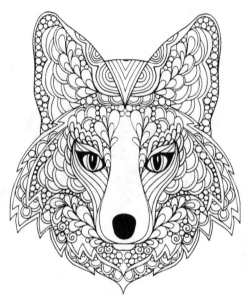

*Animal Design 7*

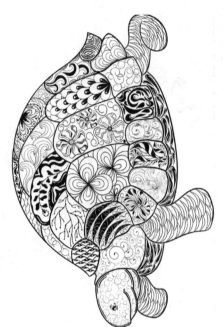

*Animal Design 8*

*Animal Design 10*

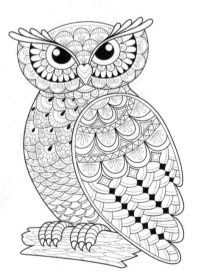

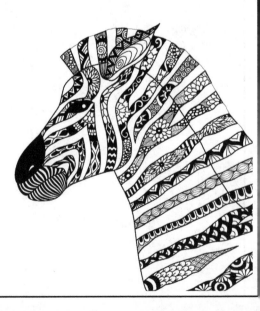

*Animal Design 9*

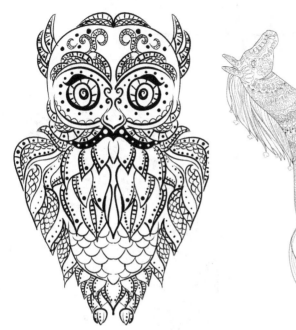

*Animal Design 11*

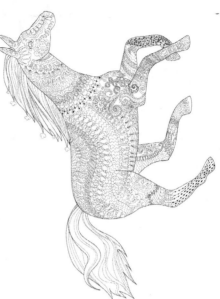

*Animal Design 12*

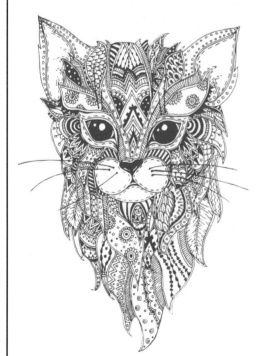

*Animal Design 13*

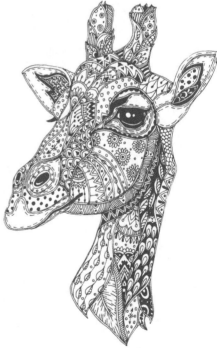

*Animal Design 14*

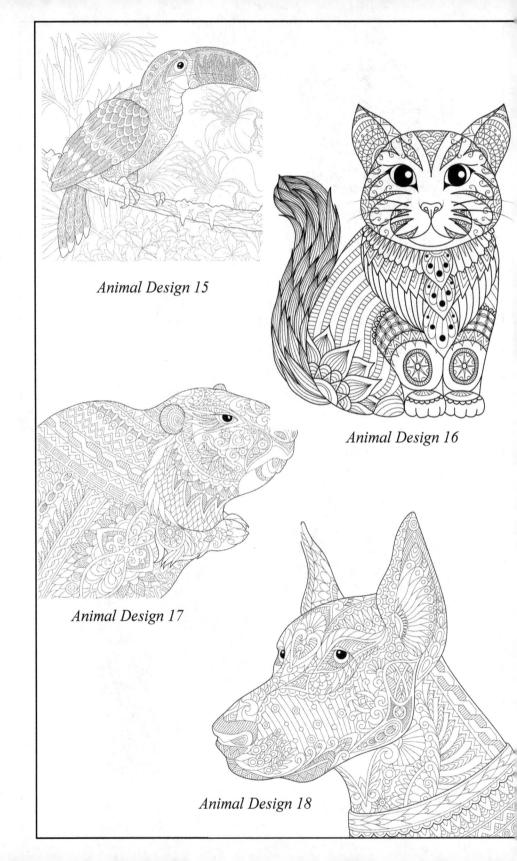

*Animal Design 15*

*Animal Design 16*

*Animal Design 17*

*Animal Design 18*

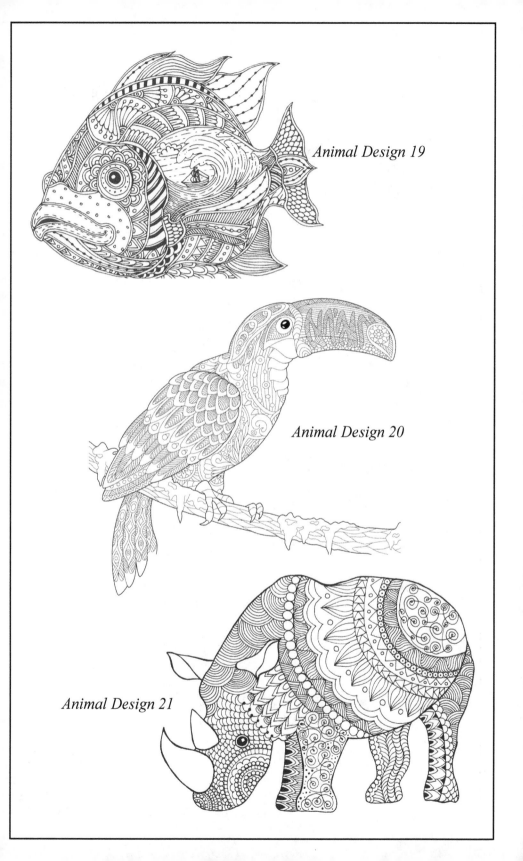

*Animal Design 19*

*Animal Design 20*

*Animal Design 21*

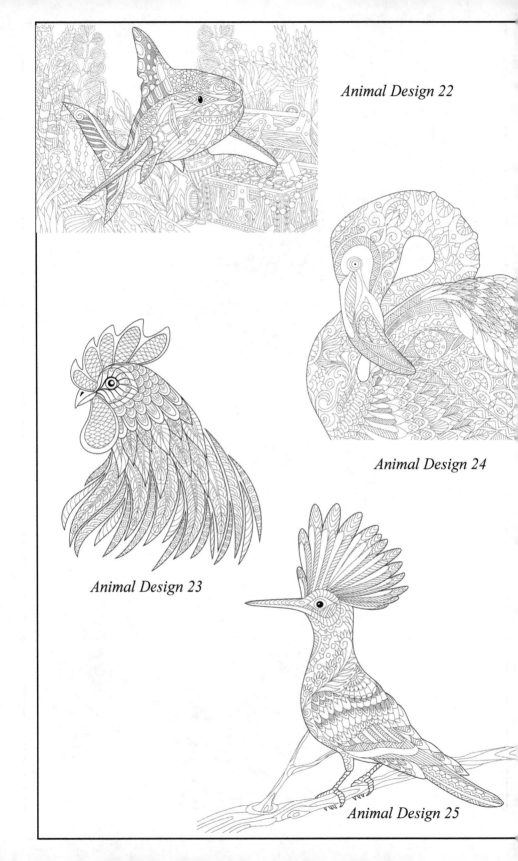

*Animal Design 22*

*Animal Design 24*

*Animal Design 23*

*Animal Design 25*

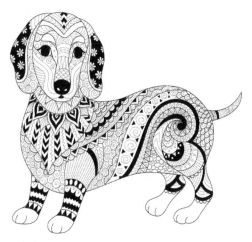

*Animal Design 26*

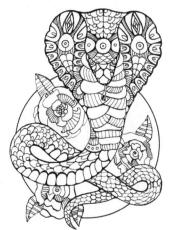

*Animal Design 27*

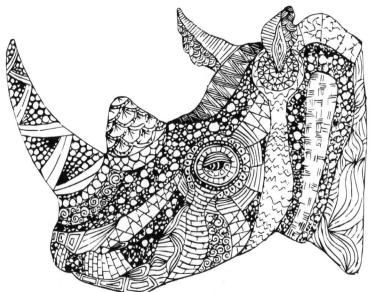

*Animal Design 28*

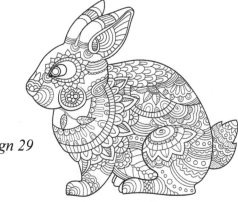

*Animal Design 29*

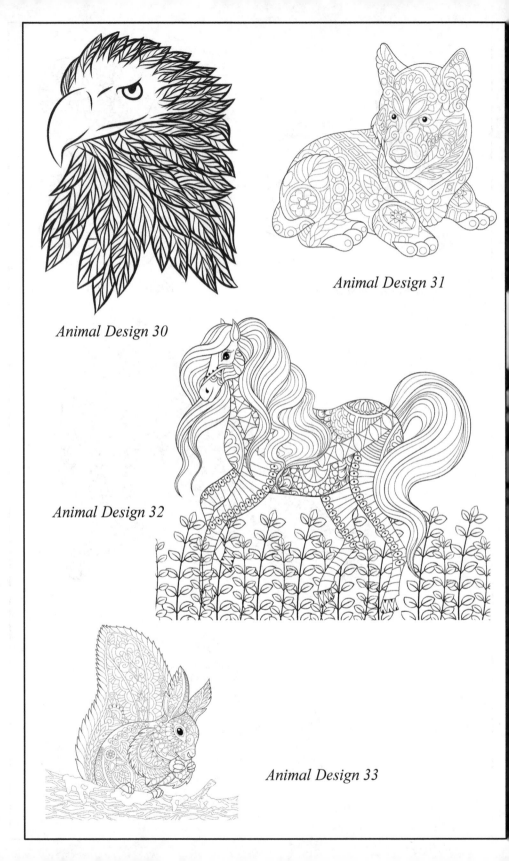

*Animal Design 30*

*Animal Design 31*

*Animal Design 32*

*Animal Design 33*

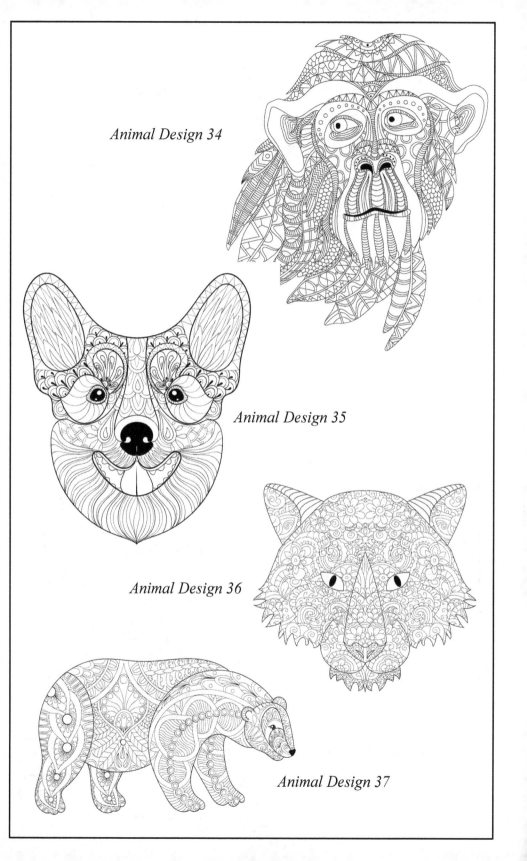

*Animal Design 34*

*Animal Design 35*

*Animal Design 36*

*Animal Design 37*

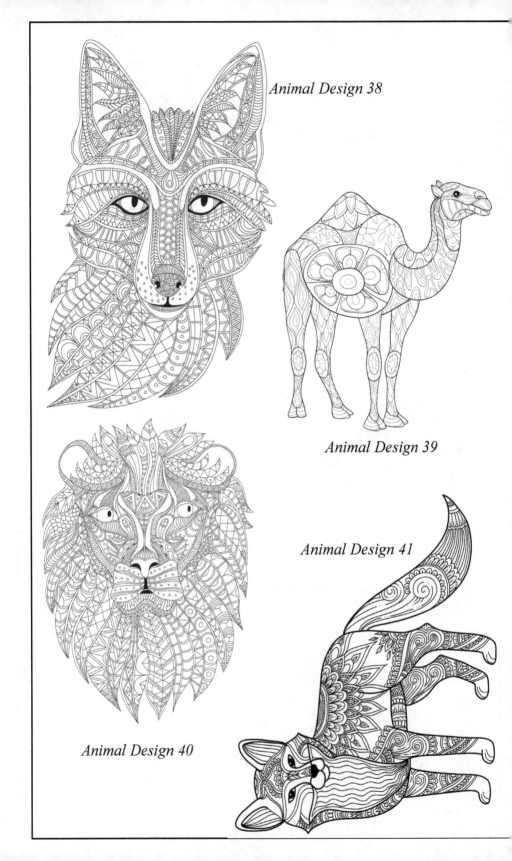

*Animal Design 38*

*Animal Design 39*

*Animal Design 41*

*Animal Design 40*

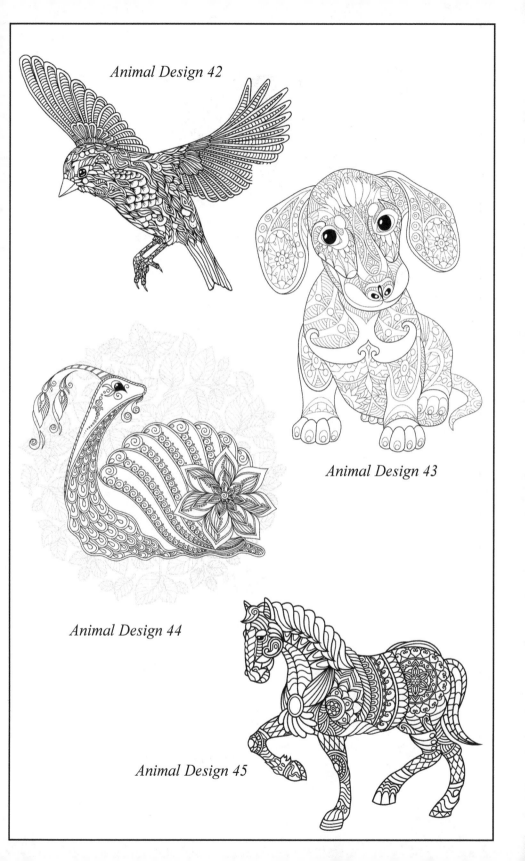

*Animal Design 42*

*Animal Design 43*

*Animal Design 44*

*Animal Design 45*

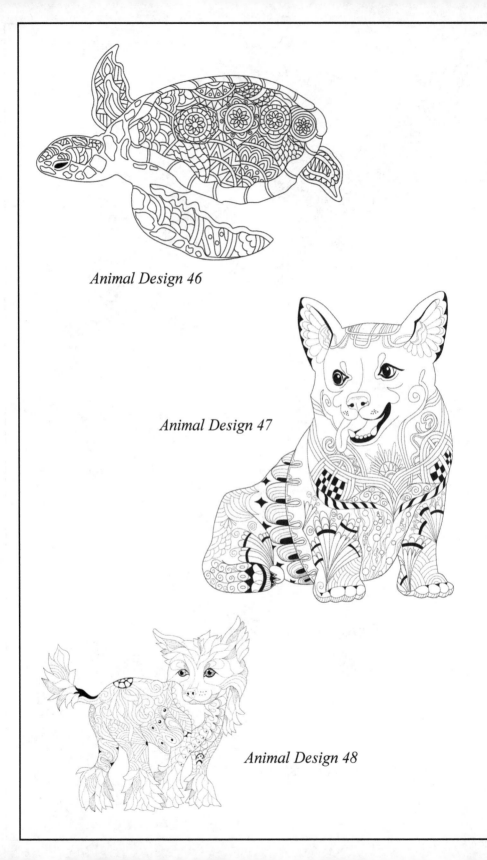

*Animal Design 46*

*Animal Design 47*

*Animal Design 48*

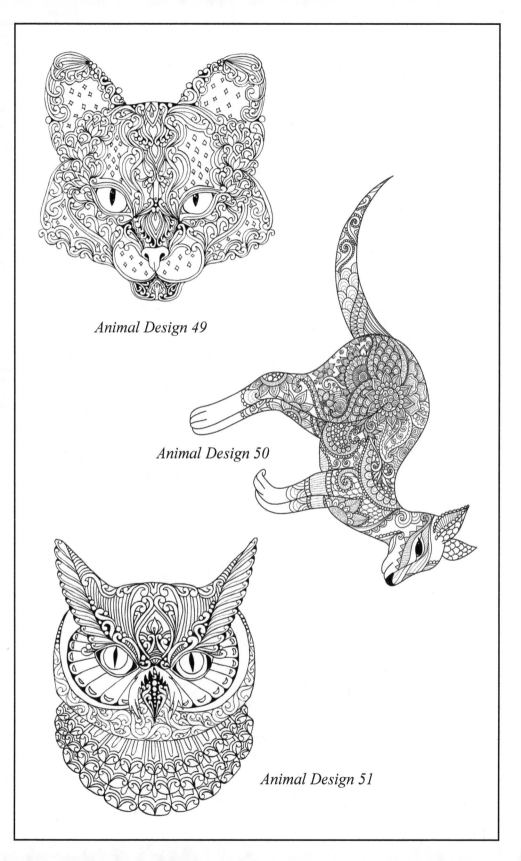

*Animal Design 49*

*Animal Design 50*

*Animal Design 51*

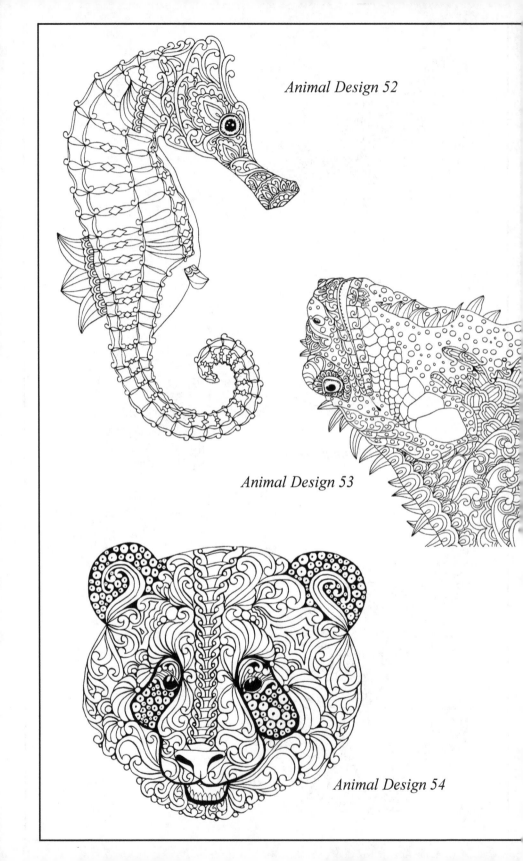

*Animal Design 52*

*Animal Design 53*

*Animal Design 54*

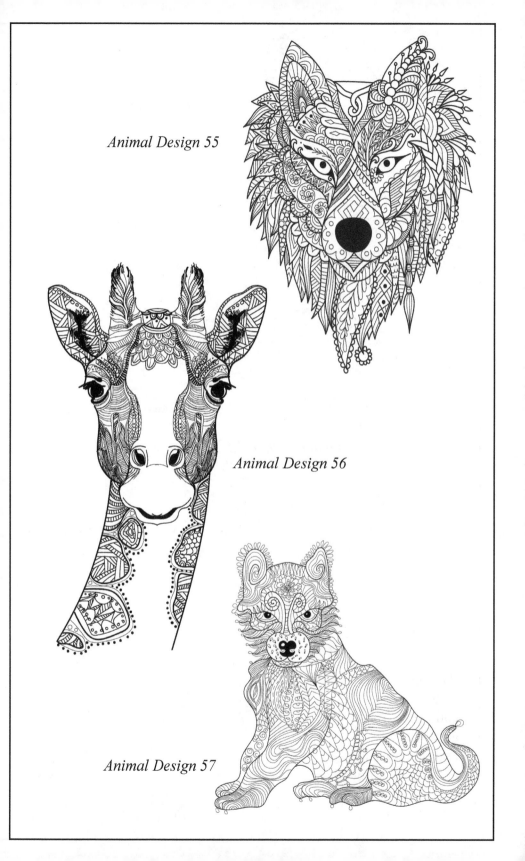

*Animal Design 55*

*Animal Design 56*

*Animal Design 57*

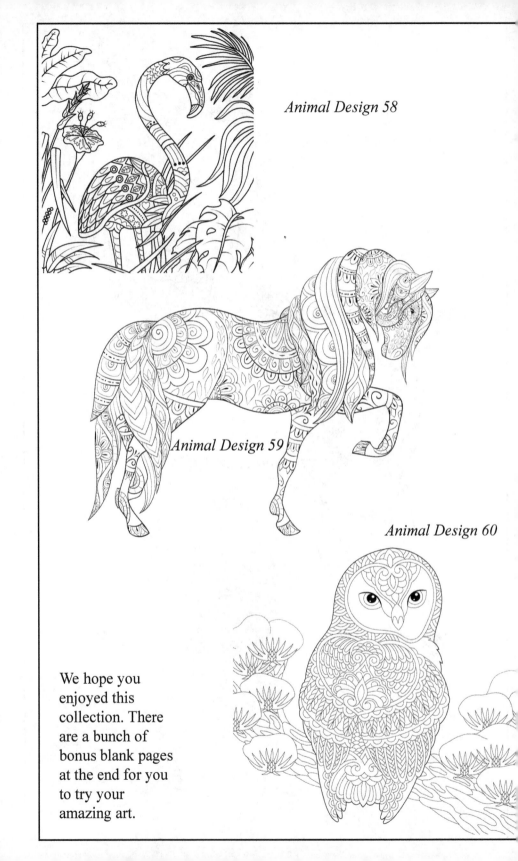

*Animal Design 58*

*Animal Design 59*

*Animal Design 60*

We hope you
enjoyed this
collection. There
are a bunch of
bonus blank pages
at the end for you
to try your
amazing art.

CPSIA information can be obtained
at www.ICGtesting.com
Printed in the USA
LVHW021637180421
684817LV00012B/146